NEVER NEVER QUIT

A PHOTOGRAPHIC CELEBRATION OF 'COURAGE' IN AMERICAN SPORTS

by
MIKE SHIELDS

Great Quotations Publishing Company

Photo Acknowledgments

J.R. Eyerman, Life Magazine ©
1950 Time Inc. (*Jackie Robinson*)

Ralph Crane, Life Magazine ©
1960 Time Inc. (*Golf Ball in Flight*)

Bob Gomal, Life Magazine ©
1961 Time Inc. (*Mickey Mantle*)

Mark Kaufman, Life Magazine ©
1962 Time Inc. (*Football Player's Arms*)

A.Y. Owen, Life Magazine ©
1966 Time Inc. (*Jim Ryun*)

AP/Wide World Photos, 2/80
(*U.S. Hockey*)

AP/Wide World Photos, 12/67
(*Bart Starr/Green Bay Packers*)

AP/Wide World Photos, 6/60
(*Wilma Rudolph*)

AP/Wide World Photos, 10/51
(*Bobby Thompson/New York Giants*)

AP/Wide World Photos, 4/83
(*Lorenzo Charles, North Carolina State*)

AP/Wide World Photos, 6/69
(*Pancho Gonzales*)

Carol Hogan, People Weekly 10/82
(*Julie Moss, 1981 Ironman Triathlon*)

Robert Riger, NFL Photos 12/58
(*Johnny Unitas*)

The Allens/NFL Photos, 9/85
(*Jim Mc Mahon, TB 28 Chicago 38*)

AP/Wide World Photos, 9/72
(*Mark Spitz, 1972 Olympics*)

David Hume Kennerly,
Gamma Liaison, 8/84
(*Jeff Blatnick, 1984 Summer Olympics*)

Robert Stinnett, Oakland Tribune
(*California's Winning Touchdown
Against Stanford, 1982*)

George Long, Sports Illustrated, 1966
(*Bob Stiles, UCLA 1966 Rose Bowl Game*)

Paul Kennedy, Sports Illustrated, 1978
(*Craig Nettles, New York Yankees*)

Richard Mackson, Sports Illustrated, 6/82
(*Tom Watson, U.S. Open*)

UPI/Bettmann, Newsphotos, 10/64
(*William Mills, Olympic Record*)

UPI/Bettmann, Newsphotos, 2/64
(*Cassius Clay, Heavyweight Champion of the World*)

UPI/Bettmann, Newsphotos, 10/60
(*Bill Mazeroski, Pittsburg Pirates*)

UPI/Bettmann, Newsphotos, 10/56
(*Don Larsen, New York Yankees*)

UPI/Bettmann, Newsphotos, 10/46
(*Enos "Country" Slaughter, World Series*)

UPI/Bettmann, Newsphotos, 8/48
(*Bob Mathias, Olympic Decathlon*)

We are grateful to the following organizations for
permission to reprint their copyrighted materials:
UPI/Bettmann, Life, Wide World Photos, South Bend Tribune,
Sports Illustrated, Texas Monthly, Carol Hogan, Oakland
Tribune, NFL Properties, and Gamma/Liaison.

NEVER NEVER QUIT by Mike Shields

ISBN: 0-931089-80-8

4 5 6 7 8 9 10 11 12

Printing/AK/Year 95 94 93

*Dedicated to those who believe
that "impossible" dreams do come true,
and that life's battles don't always
go to the strongest or fastest
but to those who fight on.*

"On the ballfield he is
perpetual motion itself . . .
he would run through a brick wall,
if necessary, to make a catch,
or slide into a pit of ground glass
to score a run."

-Edward Daley, sportswriter,
on Enos Slaughter

THE SPIRIT OF ST. LOUIS
Unfazed after doctors warn him that his badly hemorrhaged arm may have to be amputated if bruised further, St. Louis Cardinal outfielder Enos Slaughter races from first base to home with the game-winning run on a "single" to left center field off the bat of Harry Walker enabling the Cardinals to defeat the Boston Red Sox in the seventh and deciding game of the 1946 World Series.

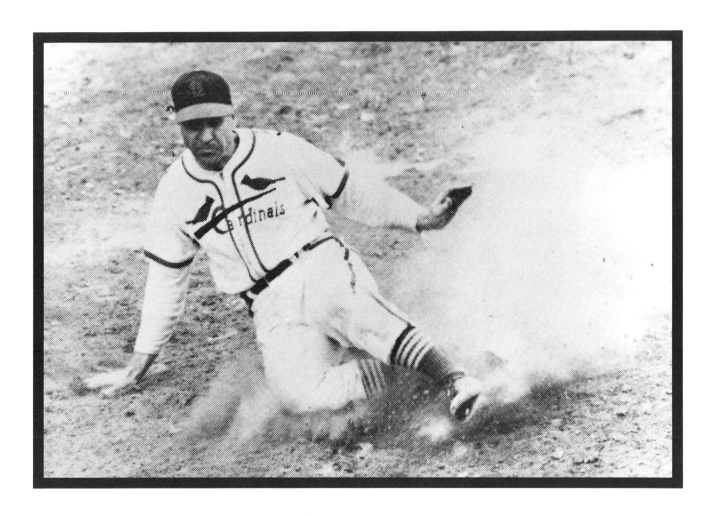

"Ask not for victory,
ask for courage.
For if you can endure
you bring honor to us all,
even more
you bring honor to yourself."

-From *The Deacatlon*

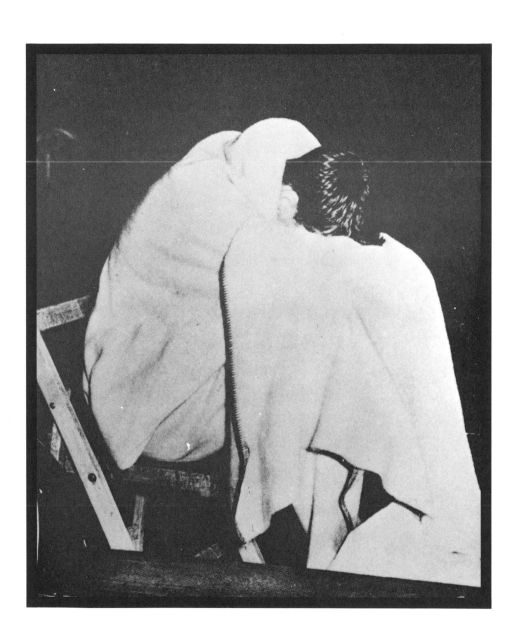

"Every man has an obscure respect
for courage in others,
especially if it is moral courage,
the rarest and most difficult
sort of bravery . . .
It makes the very brute understand
that this man is more than a man."

-Passage from *The Life of Christ,*
read by Branch Rickey, Brooklyn
Dodgers owner, to Jackie Robinson
the day he signed a Dodger contract

PROFILE IN COURAGE
Overcoming viscious verbal abuse, racial
slurs, beanballs, brushbacks, and even
death threats, Jackie Robinson of the
Brooklyn Dodgers, who just two years
earlier became the first black man to play
in the major leagues, is voted the league's
Most Valuable Player award for 1949 after
winning the major league batting
championship, leading the league in
stolen bases, and perhaps most important
of all for providing the leadership and
inspiration which carry the Dodgers to the
National League pennant.

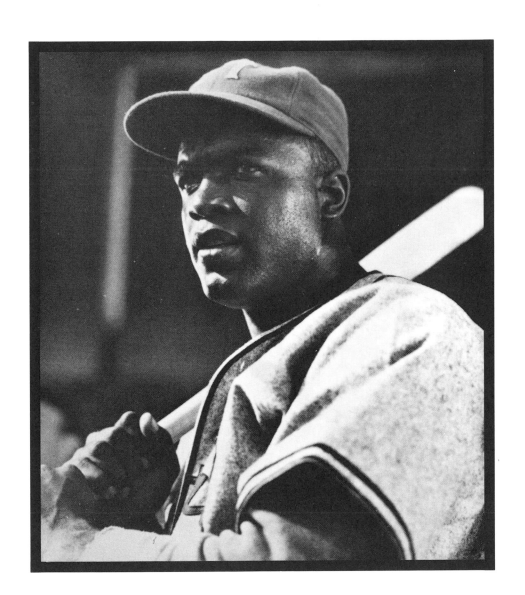

"Branca throws.
Thomson hits a long drive . . .
it's gonna be . . . I believe . . .
the Giants win the pennant!
The Giants win the pennant!
The Giants win the pennant!
The Giants win the pennant! . . .
I don't believe it. I don't believe it.
I will not believe it."

-Russ Hodges,
Giants announcer

YOU GOTTA BELIEVE
Although pronounced out of the pennant race just six weeks earlier when they trail the league-leading Brooklyn Dodgers by 13½ games, the New York Giants storm back to win the 1951 National League pennant on the strength of Bobby Thomson's game-winning 3-run homer in the bottom of the ninth inning of the third and deciding playoff game against the once invincible Dodgers.

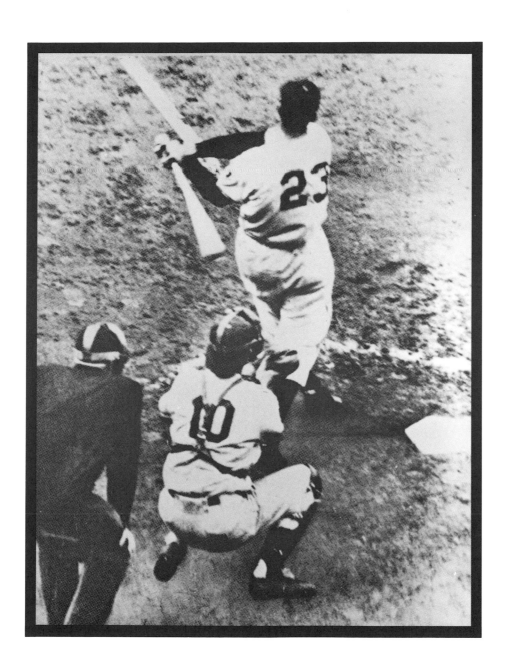

"Good things come to those who wait."

-Harrison Dillard

AT LAST FIRST
Harrison "Bones" Dillard captures the 110
meter hurdle event in the 1952 Olympics to
make up for his heartbreaking failure to win
a Gold Medal in 1948 when despite winning
an unprecedented 82 consecutive races and
considered the greatest hurdler in history, he
fails to qualify for the event in the Olympic
trials after he hits a hurdle and falls to
the ground.

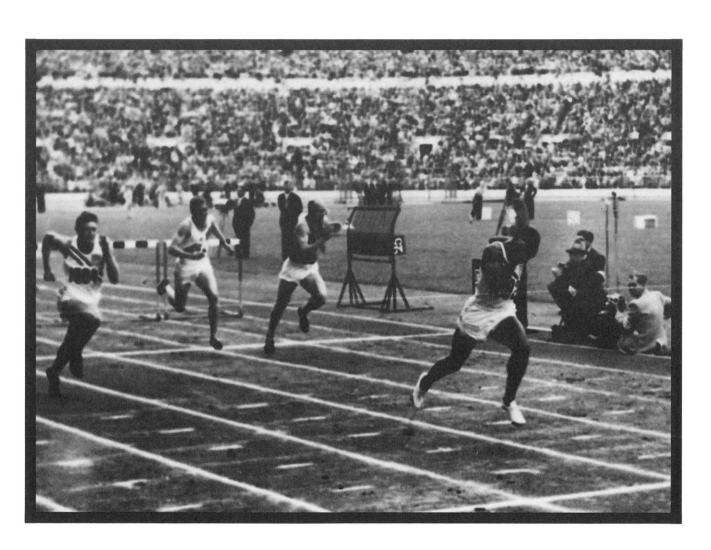

"This is next year!"

-Johnny Podres,
Brooklyn Dodgers
pitcher

JOY IN MUDVILLE
After failing in all five of their World Series appearances since 1941, the Brooklyn Dodgers behind the brilliant pitching of Johnny Podres and timely hitting of Duke Snider (#4) defeat their cross-town archrivals, the New York Yankees, four games to three to capture the 1955 World Series and their first world championship.

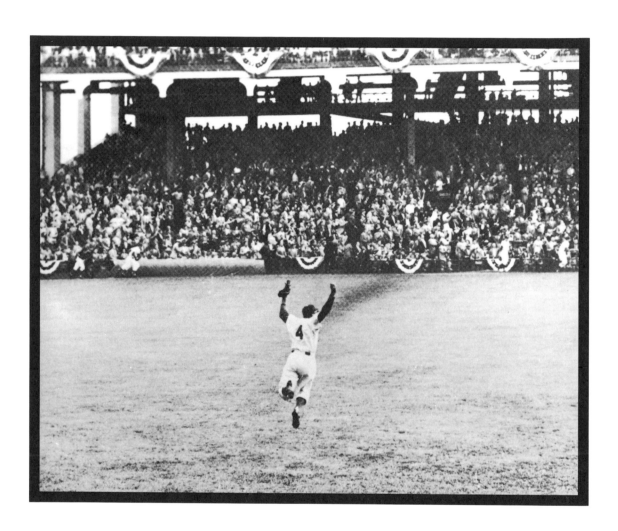

"Without heroes,
we are all plain people
and don't know
how far we can go."

-Bernard Malamud,
The Natural

CONQUERING HERO
Despite suffering from several serious
disabilities including an arrested case of
osteomyelitis in his left ankle and arthritis
in his right knee, New York Yankee
outfielder Mickey Mantle captures the
American League "Triple Crown" in 1956
by batting .353, driving in 130 runs, and
hitting 52 home runs including one that
misses by just inches of going completely
out of Yankee Stadium — a feat no player
before or since comes close to
duplicating.

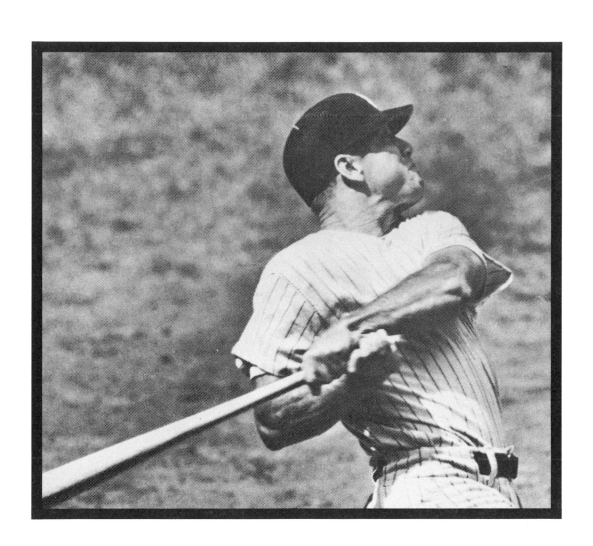

"I'm gonna beat those guys tomorrow."

-Don Larsen,
New York Yankees
pitcher

THE PERFECT ENDING
Although he is knocked out in the second inning of the second game of the 1956 World Series by the heavy-hitting Brooklyn Dodgers, New York Yankee pitcher Don Larsen comes back just four days later to defeat the Dodgers 2-0 by retiring 27 Brooklyn batters in succession — an almost unimaginable perfect game!

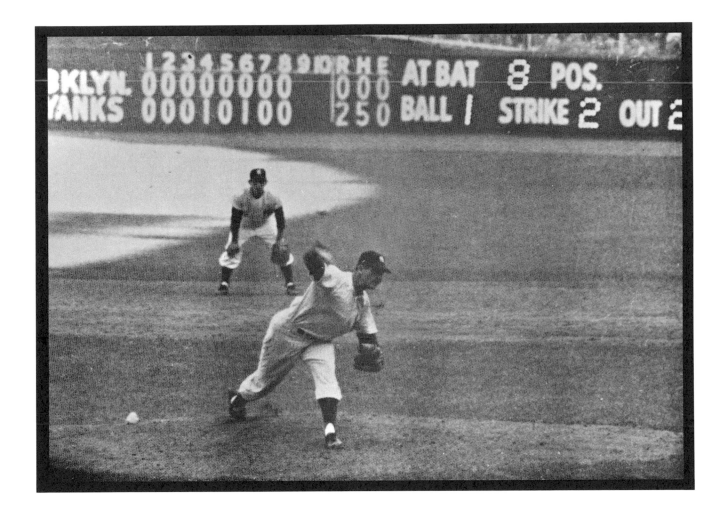

IRISH STOP OKLAHOMA, 7-0

-Chicago Tribune
page one headline
November 17, 1957

FIGHT BEATS MIGHT
Rated 18-point underdogs prior to their 1957 contest against Oklahoma, the Fighting Irish of Notre Dame defeat the top-ranked Sooners in Norman, Oklahoma by a score of 7-0 to not only snap the Sooners' epic 47-game winning streak but also repay them for the 40-0 drubbing this same Oklahoma team had inflicted upon them just one year earlier in South Bend.

"I'm sorry but we can't use you."

-Walt Kiesling,
Pittsburgh Steelers
coach, to Johnny Unitas
in 1955

UP UP AND AWAY
Just three years after being cut by the Pittsburgh Steelers and relegated to playing for a Pittsburgh semi-pro team, Baltimore Colt quarterback Johnny Unitas completes 26 of 40 passes for 322 yards to lead Baltimore to a 23-17 overtime win over the New York Giants in the 1958 NFL championship game.

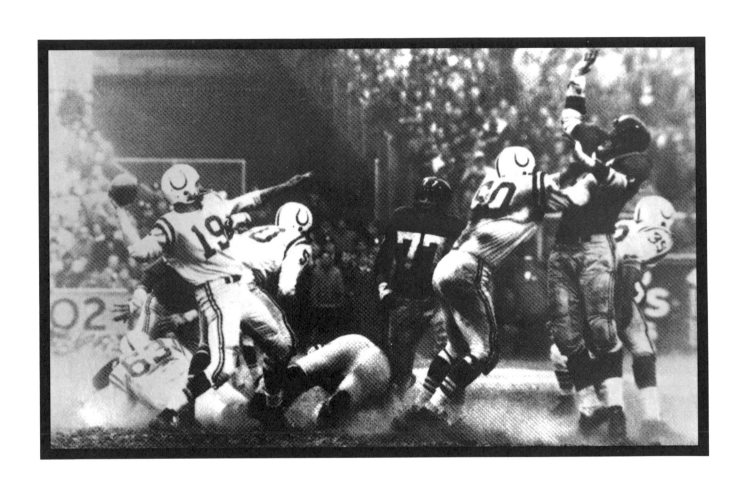

"I wasn't going to lead a life of dear and near misses."

-Arnold Palmer

CHARGE
In fifteenth place after three rounds of the 1960 U.S. Open in Denver, Colorado, Arnold Palmer begins his final round with a tremendous "go for broke" 300-yard drive to the green to birdie the hole and gather enough momentum to allow him to birdie 5 of the next 6 holes and win the tournament by 2 strokes.

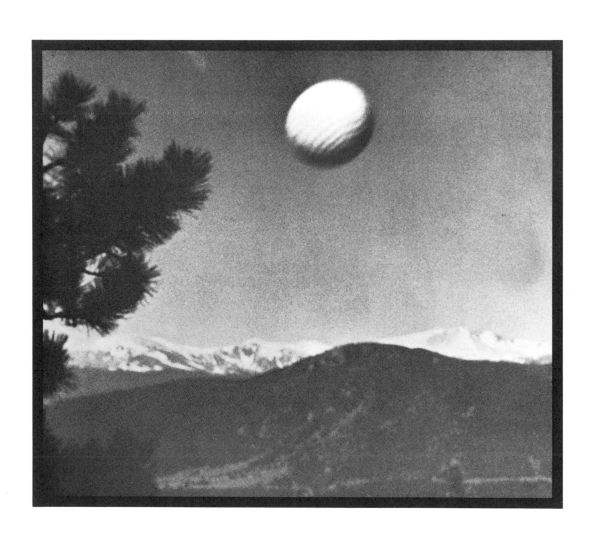

"My mother taught me very early
to believe I could achieve
any accomplishment I wanted to.
The first was to walk
without braces."

-Wilma Rudolph

ONE STEP AT A TIME
Unable to walk without braces until the
age of 11 because of a series of childhood
illnesses, Wilma Rudolph sprints to victory
at the 1960 Rome Olympics in the 100
meter and 200 meter dashes and anchors
the record-setting 400 meter relay team to
capture an unprecedented third Gold
Medal.

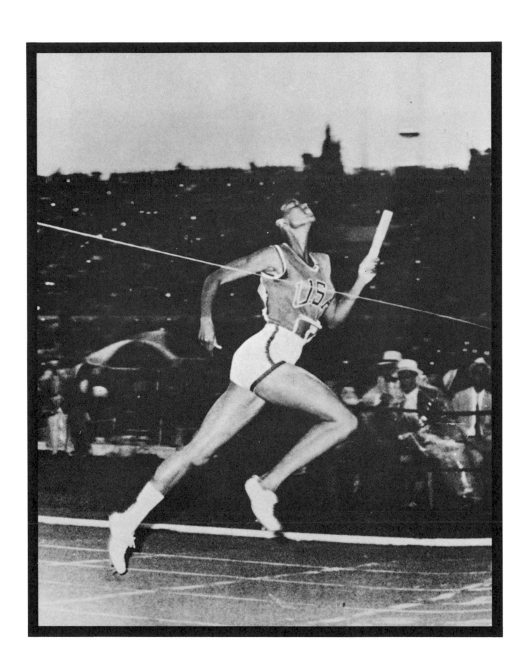

"The Yankees set all the records, but we won the most games."

-Danny Murtaugh,
Pittsburgh Pirates
manager

LAST LAUGH
Although beaten in three previous World Series games by the humiliating scores of 16-3, 10-0 and 12-0, the Pittsburgh Pirates on the strength of Bill Mazeroski's ninth inning home run come back in game seven of the 1960 World Series to defeat the record-setting New York Yankees by a score of 10-9 and capture their first world championship in 35 years.

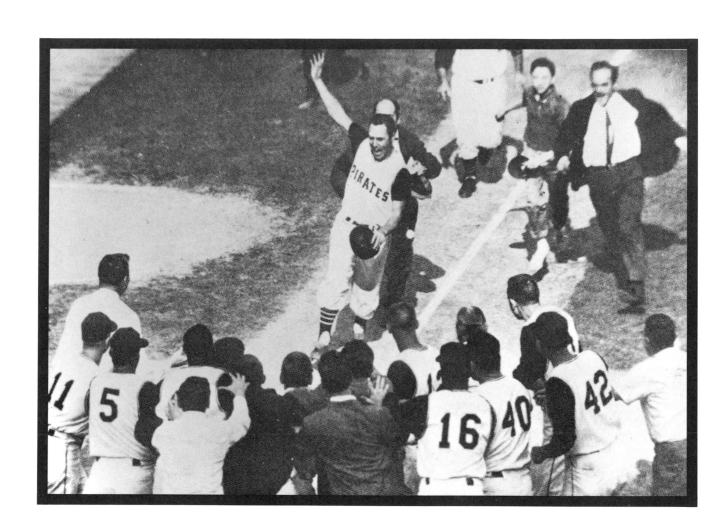

"I'm going to upset the whole world."

-Cassius Clay

ON TOP OF THE WORLD
Despite a pre-fight poll which indicates that 44 of the 45 writers covering the fight predict him to be defeated, Cassius Clay (later Muhammad Ali) scores a convincing technical knockout of Sonny Liston in their 1964 bout to capture the heavyweight championship of the world.

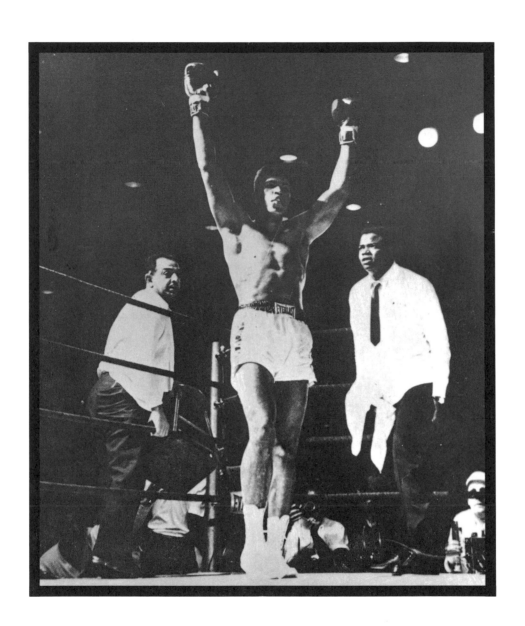

"Who are you?"

-Olympic official
to Billy Mills
after the race

RUNNING BRAVE
Coming from 15 meters back on the final
lap, an unknown but determined American
Indian named Billy Mills (#722) races past
world record-holder Ron Clarke of
Australia to capture the Gold Medal in the
10,000 meter run at the 1964 Tokyo
Olympics.

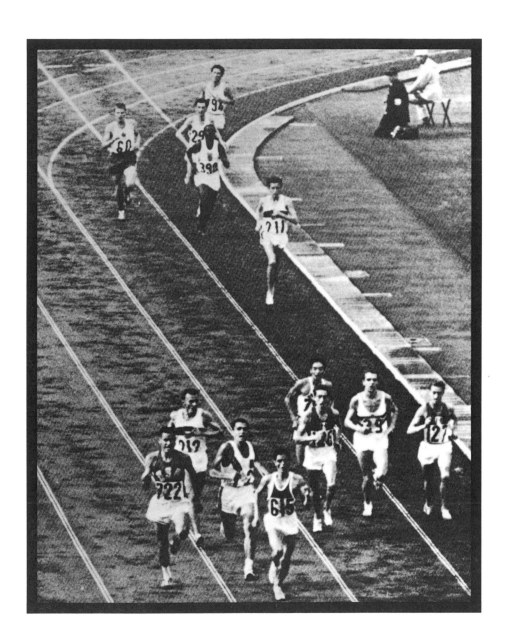

"The important thing
in the Olympic games is
not winning but taking part.
The essential thing in life is
not conquering but fighting well."

-Baron de Coubertin,
The Olympic Creed

TRUE GRIT
Advised by his doctors not to compete
after he tears cartilage in his ribs just
days before, discus thrower Al Oerter,
despite excruciating pain, unleashes a
toss of 200 feet on his second to last
attempt at the 1964 Tokyo Olympics to
defeat world record-holder Ludvik Danek
of Czechoslovakia by less than 2 inches
and win his third consecutive Gold Medal.

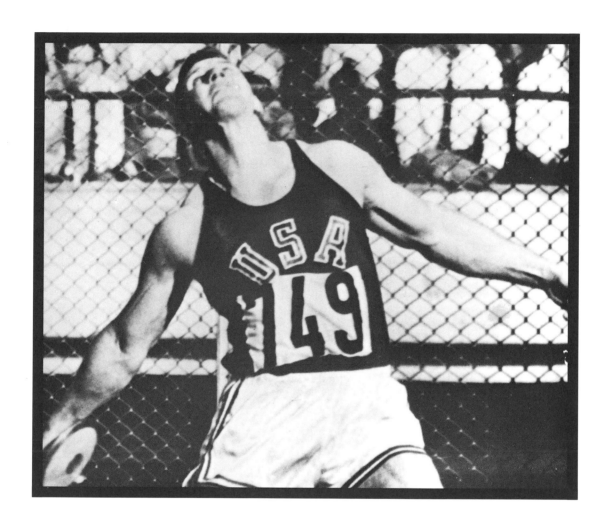

"To be realistic about it, the championship game of 1964 already has been played. Baltimore won it in October by beating Green Bay for the second time."

-Edwin Shrake, sportswriter, on Cleveland's chances against Baltimore

FIGHTIN' WORDS
Given no chance for victory by the "experts", the Cleveland Browns, a team having the worst defense in the league, stun the heavily-favored Baltimore Colts, a team with the best offense in the league, by a score of 27-0 on the strength of three touchdown passes from quarterback Frank Ryan to end Gary Collins to capture the 1964 NFL championship.

"You can always pitch better."

-Sandy Koufax

KING OF THE HILL
Just two days after shutting out the Minnesota Twins 7-0 on 4 hits in game 5 of the 1965 World Series, Los Angeles Dodger pitcher Sandy Koufax powers his way through the heavy-hitting Twins lineup to win game 7 by a score of 2-0 and clinch the world championship for the Dodgers; despite pitching with a throbbing arthritic elbow which will end his baseball career just one year later, in the decisive seventh game, Koufax strikes out 10 and allows — just 3 hits!

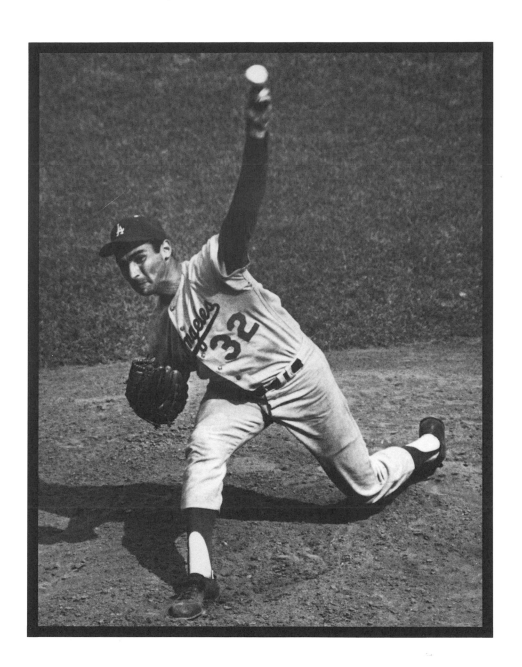

"If one less person had put out one less percent we would have lost."

-Tommy Prothro,
UCLA football
coach

SCHOOL OF HARD KNOCKS
UCLA's 5'9" 170-pound cornerback Bob Stiles "walks" off the field just moments after he is knocked unconscious on his game-saving goal line tackle of Bob Apisa, Michigan State's 220-pound fullback, in the closing seconds of the 1966 Rose Bowl game which UCLA wins 14-12 over Michigan State, a team thought by many to be the greatest college football team ever assembled.

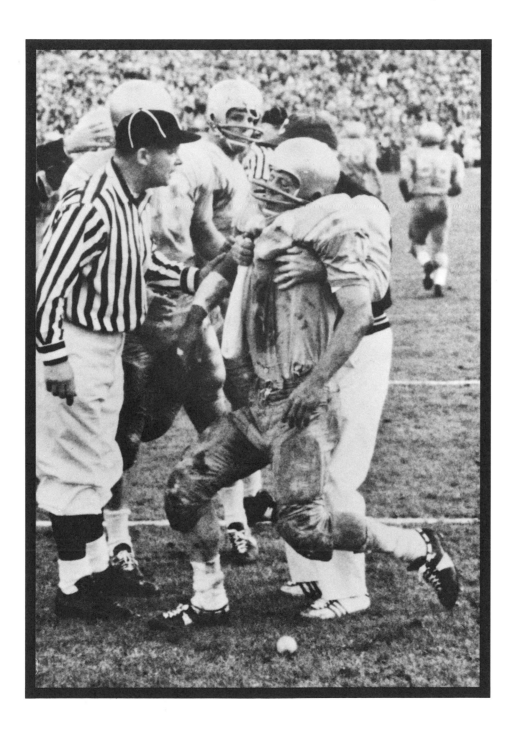

"The climate in Kansas varies from ice, deep snow, and blizzard in winter to 100 degree heat in summer. Through it all, Ryun ran. Every day, twice a day. Hot or cold, rainy or sun, he ran."

-Phil Pepe, sportswriter,
on Jim Ryun

THE ROAD LESS TRAVELED
Running through the deserted streets of his native Wichita, Kansas on his daily pre-dawn training run, 19-year old miler Jim Ryun relentlessly pursues his goal of becoming the first American in 30 years to hold the world record in the mile run, a goal he will reach just three months later in June, 1966 by running the mile in the world record time of 3 minutes 51.3 seconds.

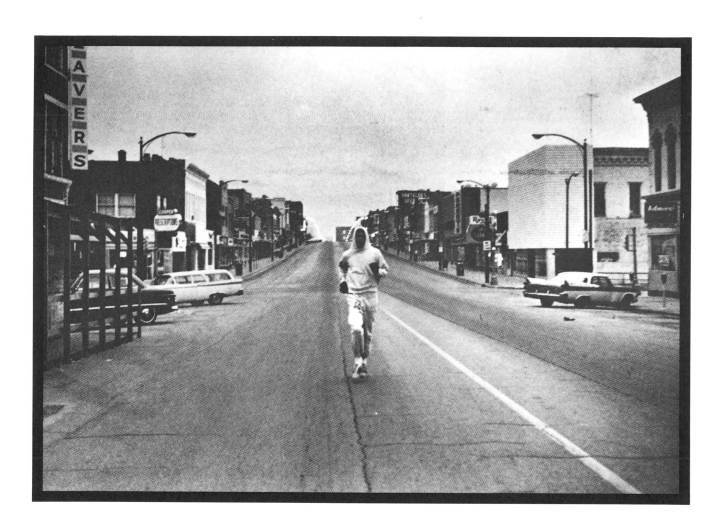

"The real glory is being knocked to your knees and then coming back. That's real glory. That's the essence of it."

-Vince Lombardi,
Green Bay Packers coach

THE PACK COMES BACK
With the temperature and wind chill at record low levels and the field a sheet of ice, the Green Bay Packers culminate a 65-yard last minute drive when quarterback Bart Starr (#15) scores from the 1 yard line on the final play of the game to give the Packers a 21-17 come-from-behind victory over the Dallas Cowboys in the 1966 NFL championship game.

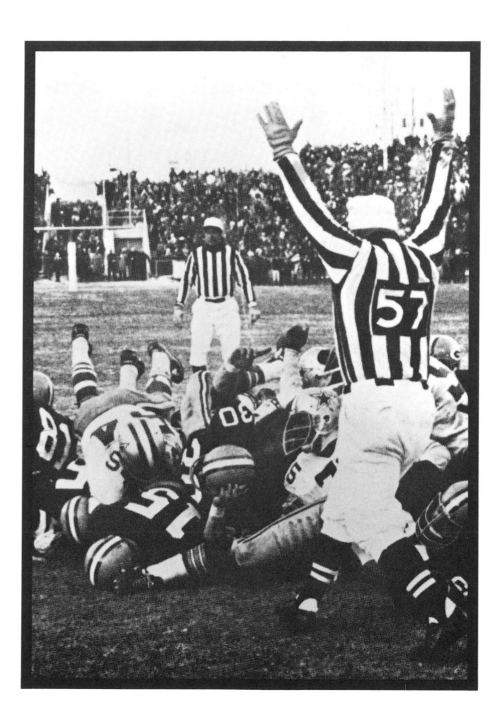

"I just play with what I have left."

-Pancho Gonzales

WINNING THE OLD FASHIONED WAY
After losing the first two sets 22-24 and 1-6, 41-year old Pancho Gonzales storms back against Charlie Pasarell, a player 16 years his junior, to take the next three sets 16-14, 6-3, and 11-9 and advance in the 1969 Wimbledon tennis tournament; not once but twice in the fifth and deciding set, an exhausted Gonzales is down love-40 and facing triple match point but comes back each time to win the game.

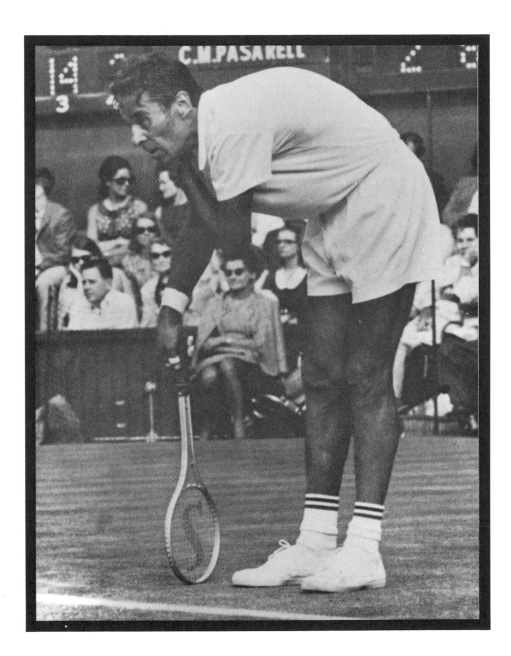

"As long as a person doesn't admit
he is defeated, he is not defeated —
he's just a little behind
and isn't through fighting."

-Darrell Royal,
Texas football coach

FIGHT TO THE FINISH
Faced with 4th and 2 at the Notre Dame
10 yard line and time running out in the
1970 Cotton Bowl game, Texas quarter-
back James Street (#16) hits end Cotton
Speyer at the 2 yard line for a crucial first
down which allows the top-ranked Long-
horns to score the game-winning touch-
down just seconds later and claim the
national championship of college football.

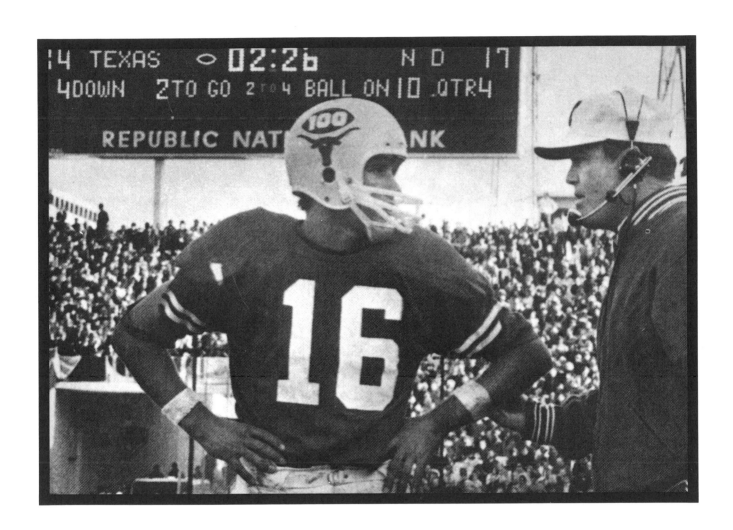

"I'm making no predictions.
I feel fine. I feel great.
I'll just swim my best."

-Mark Spitz, 1972

SILENCE IS GOLDEN
After completely failing to live up to his prediction at the 1968 Mexico City Olympics that he would capture 5 individual Gold Medals in the swimming events, a wiser and more determined Mark Spitz comes back four years later at the 1972 Munich Olympics to win an unprecedented 7 Gold Medals including 5 individual Gold Medals — all in Olympic and world record time.

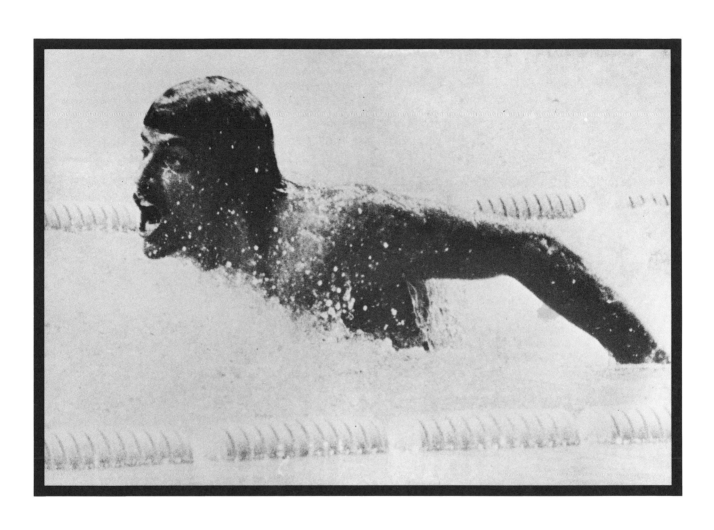

"He was hustling, and good things happen to people who hustle."

-Chuck Noll,
Pittsburgh Steelers
coach, on Franco Harris'
touchdown "reception"

GREAT EXPECTATIONS
On a 4th and 10 play with just 22 seconds left in the game and his team trailing by a point, Pittsburgh Steeler halfback Franco Harris grabs a deflected pass just as it is about to hit the ground and romps 42 yards untouched into the end zone to give the Steelers a 13-7 victory over the stunned Oakland Raiders in their 1972 AFC divisional playoff game.

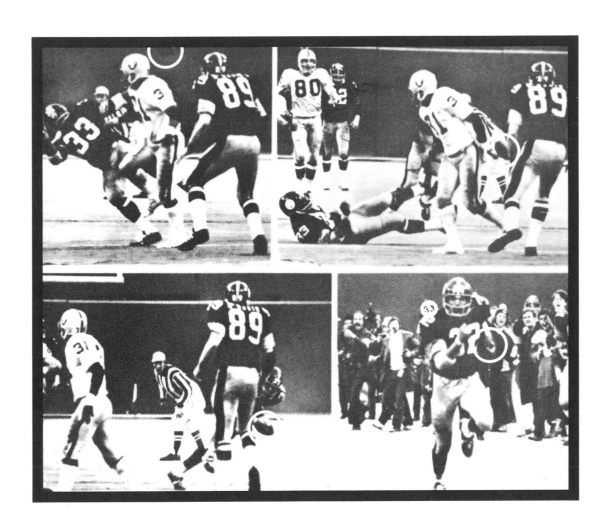

"It ain't over till it's over."

-Yogi Berra,
New York Yankees coach

HANGING TOUGH
Trailing first place Boston by 14½ games in late July, the New York Yankees behind the brilliant play of players such as third baseman Craig Nettles stage a remarkable second half comeback to win the 1978 American League pennant and then go on to defeat the favored Los Angeles Dodgers in the World Series four games to two — after losing the first two games.

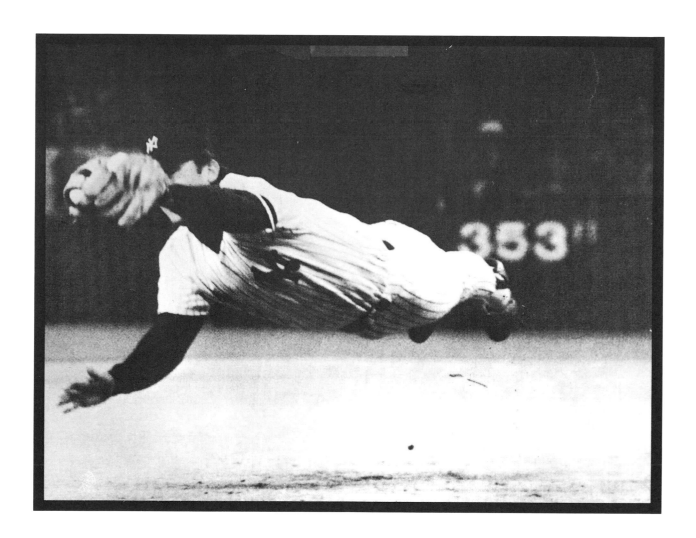

"They never give up."

-Bengt Ohlson,
Sweden's coach,
on the American
hockey team

THE RIGHT STUFF
Just two weeks after being soundly
beaten 10-3 by the world champion
Soviets in a pre-Olympic matchup, a
young but gritty U.S. Olympic hockey
team comes back to defeat not only the
Soviets but also powerful teams from
Sweden, Czechoslovakia, and Finland to
win the Gold Medal at the 1980 Lake
Placid Winter Olympics.

"Push yourself again and again . . . Don't give an inch until the final buzzer sounds."

-Larry Bird

THE MEASURE OF SUCCESS
Down three games to one in the 1981 NBA Eastern Division championship series against the Philadelphia 76ers, the Boston Celtics led by all-star forward Larry Bird (light jersey) stage two remarkable comebacks to narrowly defeat the 76ers in games 5 and 6 and then in the seventh and final game hold off a last minute Philadelphia surge to win by a single point 91-90, rejecting the powerful 76ers' one last scoring attempt — at the buzzer.

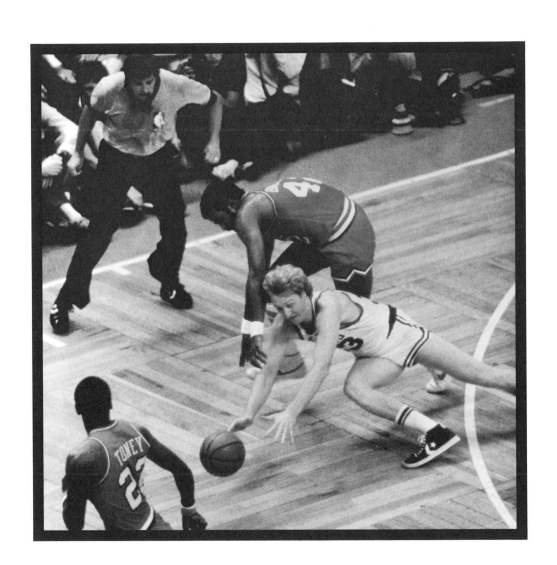

"I don't jump that well and I was real tired . . . I don't know how I caught the ball."

-Dwight Clarke

RISING TO THE OCCASION
Although still weak from a recent case of the flu, San Francisco 49er end Dwight Clarke musters one last burst of energy to make a spectacular leaping catch in the end zone with just 51 seconds left in the game to give the 49ers a 28-27 victory over the Dallas Cowboys in the 1981 NFC championship game.

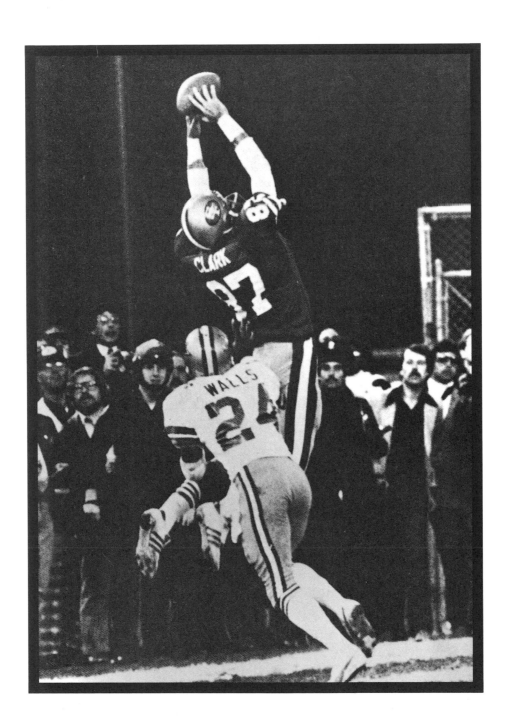

"I don't care what people thought. I wanted to finish that race."

-Julie Moss

DOWN BUT NOT OUT
An exhausted Julie Moss, who had led the competition for over 7 hours until she collapses just 50 feet from the finish line, crawls across the finish line to take second place in the women's division of the 1982 Ironman Triathlon, a grueling test of endurance and stamina made up of a 2.4 mile ocean swim, a 112 mile bicycle ride, and a 26.2 mile marathon.

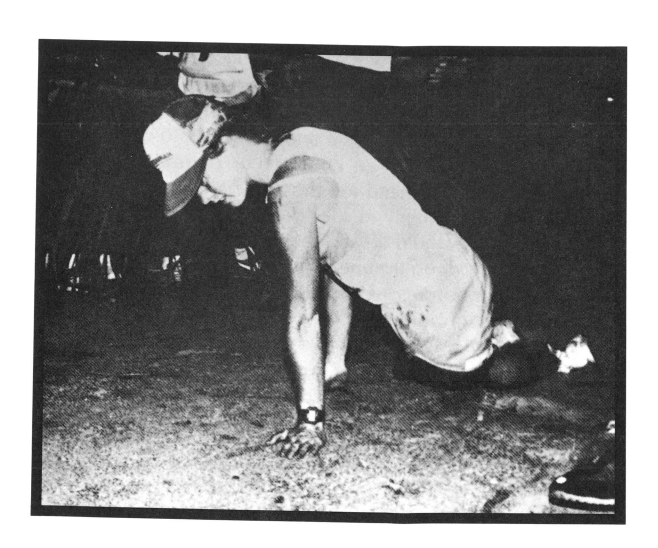

"I'm not going to get it close. I'm going to make it!"

-Tom Watson

GIVING IT YOUR BEST SHOT
Tied with Jack Nicklaus for the lead of the 1982 U.S. Open at Pebble Beach, Tom Watson chips in a 30-foot "million-to-one" shot from the rough off the severely sloping 17th green, the next to last hole of the tournament, to take a one shot lead over Nicklaus and clinch the Open championship.

"The game is 60 minutes, not 59 minutes and 56 seconds."

-Joe Kapp,
California football coach

THAT OLD COLLEGE TRY
Trailing archrival Stanford by 1 point following a Stanford field goal with just 4 seconds left in the game, the California Golden Bears receive the ensuing kickoff and take the ball on a series of no less than 5 laterals thru the Stanford defense, including the Stanford marching band, to score the winning touchdown and beat the stunned Cardinals by a score of 25-20 in their 1982 contest.

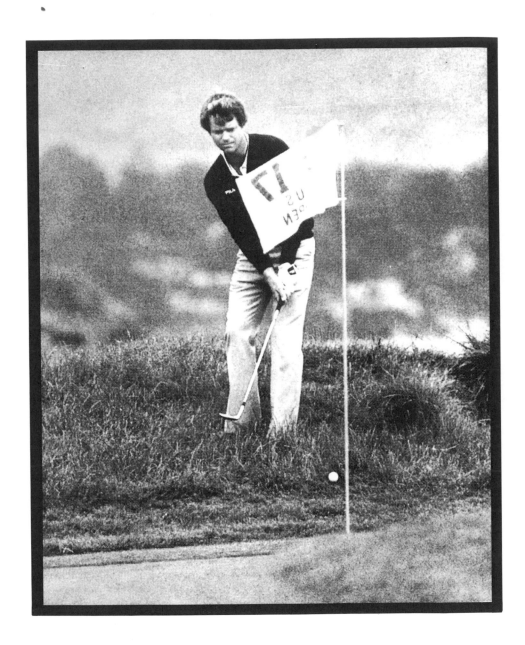

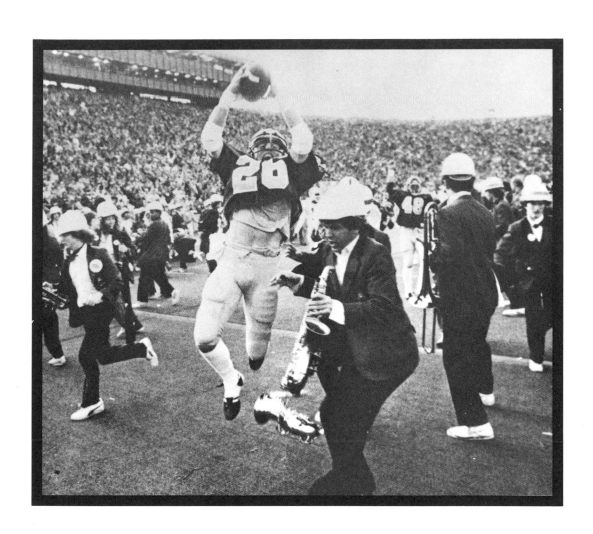

"Be a dreamer. If you don't know how to dream, you're dead."

-Jim Valvano,
N.C. State
basketball coach

THE STUFF THAT DREAMS ARE MADE OF
Rated 15-point underdogs, North Carolina
State upsets the University of Houston's
Phi Slamma Jamma team "of the 21st
century" by a score of 54-52 in the 1983
NCAA basketball championship game on
guard Dereck Wittenburg's desperation
35-foot shot which forward Lorenzo
Charles picks out of mid-air near the
basket and stuffs through just as the horn
sounds to end the game.

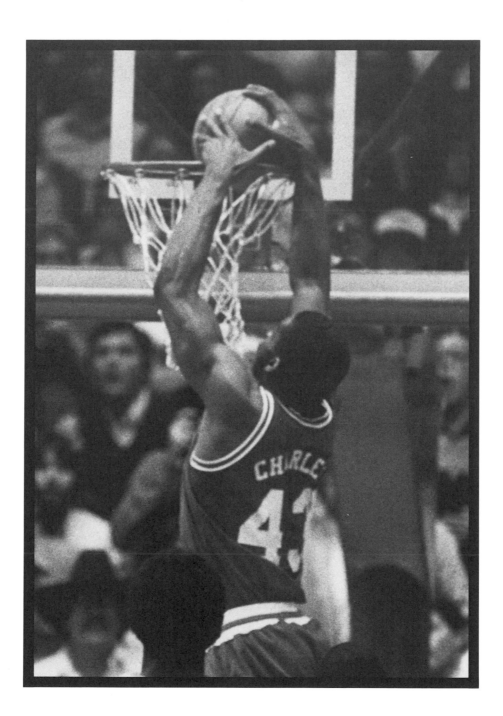

"When your back's up against the wall, you don't lay down."

-Jeff Blatnick

OUT BUT NOT DOWN
Just two years after discovering that he has Hodgkins Disease, a cancer of the lymph nodes, and forced to undergo months of debilitating treatment, Jeff Blatnick (facing camera) outpoints Sweden's Thomas Johansson, who outweighs Blatnick by 30 pounds, to win the Gold Medal in the heavyweight division of Greco-Roman wrestling at the 1984 Los Angeles Olympics.

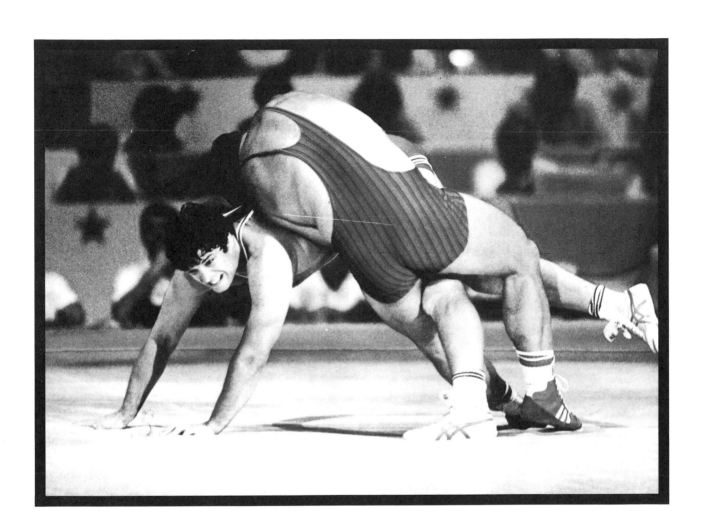

"I don't think anything is unrealistic
if you believe you can do it.
I think if you are determined enough
and willing to pay the price,
you can get it done."

-Mike Ditka,
Chicago Bears coach

BEARIN' DOWN
With the memory of a humiliating 23-0
loss to the San Francisco 49ers in the
1984 NFC championship game still clear in
their minds, the upstart Chicago Bears
roar back with a vengeance the very next
season to post a spectacular 18-1 record
capped by an awesome 46-10 victory over
the New England Patriots in Super Bowl
XX to dethrone the 49ers as world
champions.

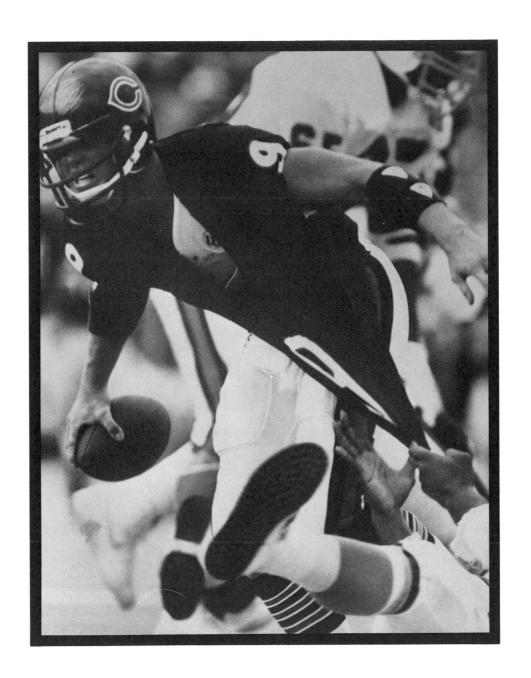

**More important than victory is effort.
At the center of effort is courage,
in sports and in life.**

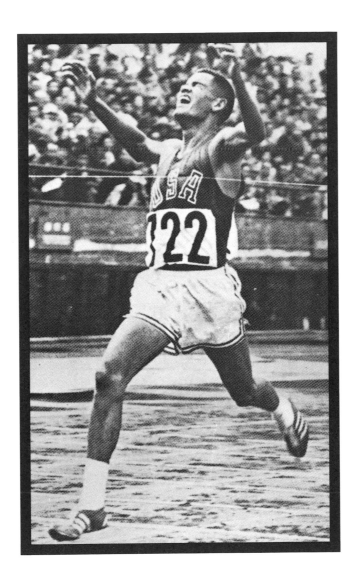